George S

Art, Animals &

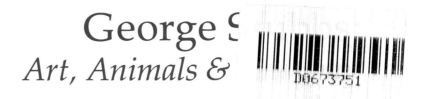

D0673751

Constance-Anne Parker

J. A. Allen

British Library Cataloguing in Publication Data

Parker, Constance-Anne
 1. Stubbs, George 2. Horses in Art
 I. Title II. Stubbs, George
 759.2 ND497.S93

ISBN 0–85131–398–1

Published in Great Britain in 1984 by
J. A. Allen & Company Limited,
1, Lower Grosvenor Place,
Buckingham Palace Road,
London, SW1W 0EL.

Production editing and design Bill Ireson.

Filmsetting by Fakenham Photosetting Limited, Fakenham, Norfolk.
Printed by St. Edmundsbury Press, Bury St. Edmunds, Suffolk.
Bound by W. H. Ware, Avon.

George Stubbs was born in Liverpool on August 29th, 1724. Most fathers want their only son to follow in their footsteps and keep the family business going. When the son has other ideas for his future there are problems.

John Stubbs had a flourishing little leather dressing business but his son George was not in the least interested in becoming a tanner. He wanted to paint, to train as an artist, not to become a clerk in the tannery office. As a very little boy he had always amused himself by drawing. Legend says that by the age of eight he was being lent anatomical specimens to draw by the local doctor. So, his passion for drawing and his interest in anatomy started at a very early age. His father quite approved of all this, but only as a hobby, not considering it a proper occupation compared with learning the tanning trade and carrying on the family business.

During his early teens George worked for his father, but only very unwillingly. It is recorded that he was "so negligent that he received some whippings". Eventually his father gave up the struggle to influence him and allowed him to leave the business and set about becoming a professional painter.

The instructor found to teach him was Hamlet Winstanley, a not very good portrait painter working for Lord Derby copying the pictures at Knowsley Hall. Stubbs was required to make a study from a painting before he could become apprenticed. His standard of work must have already been quite high for Winstanley agreed that he should work with him at Knowsley and offered him a shilling a day for his services, quite a lot of money for a lad of sixteen at that period. The arrangement did not last more than a few weeks. They fell out over which of the paintings Stubbs was to be allowed to copy—Winstanley kept the most interesting ones for himself and Stubbs didn't consider that fair.

So, at seventeen, Stubbs decided that instead of having the usual formal training copying the works of other artists, he would teach himself by

studying directly from nature. During this period his father died. Stubbs was living at home and presumably getting commissions locally for pocket money. By the time he was twenty he was away painting portraits in Wigan and in Leeds. In 1745 he moved to York, again painting portraits but also drawn to the city by his anatomical interests. There was nowhere for him to study anatomy in Liverpool, but in York there was a teaching hospital. He began to study with the surgeon Charles Atkinson, who managed to procure a body for dissection. In the 18th-century it was considered very unnatural—almost akin to witchcraft—to inquire into the human body by dissecting it and the source of bodies for this purpose were few. In fact, the teaching of anatomy was not part of the training in hospitals. Stubbs progressed rapidly to the point of being invited to give anatomy lectures to the York medical students.

The next important step in his career came when he was asked to prepare drawings for a book on midwifery being written by Dr. John Burton, one of the physicians at the York Hospital.

This work led him into strange and macabre adventures, robbing graves at night for the bodies of women who had died in childbirth so that he could dissect and make drawings of the parts particularly concerned with midwifery. All this brought Stubbs a bad name in York and was probably one of the reasons for his moving on. But before this he had problems over the book itself. No one would undertake to engrave his drawings—too indelicate a subject—and so, encouraged by Dr. Burton, Stubbs engraved the plates himself. He had never done any engraving, so he had to teach himself the craft with minimum help from a house painter friend in Leeds. The instructions were to cover a halfpenny with etching varnish, smoke it and then draw on it with a sewing needle stuck in a skewer. He was very reluctant to engrave the plates with his lack of skill and was so dissatisfied with his results that his name does not appear in the book, *An Essay towards a Complete New System of Midwifery*, which Burton published in 1751.

4

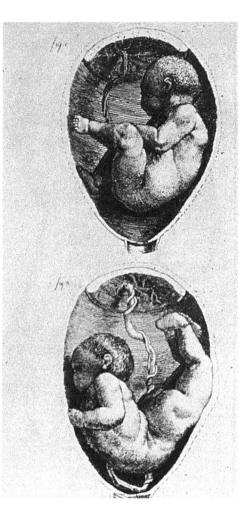

Plate from the Midwifery book, *An Essay towards a Complete New System of Midwifery*, published in 1751. *Royal Academy of Arts*

However it did give him experience which was to be very valuable in the future. The plates, in the Midwifery book, of babies in the womb, though a trifle amateurish technically, have a sculptural quality and, of course, are interesting because so little is known about Stubbs' early works.

It was during his time in York that the idea of producing a book on the anatomy of the horse came to him. At first, it seems that he had hoped for help from his anatomy students but this was not to be, and it was a number of years before he could get down to working single mindedly on the project.

After the publication of the Midwifery book Stubbs moved on to Hull where he stayed two years painting portraits. No doubt his connection with the book and the rumours of very strange goings on at night in graveyards added to his "Vile Renown" and had affected his portrait commissions in York.

He also wanted to visit Europe. In the 18th-century a visit to Italy was all but essential to an artist. Wealthy young men went on the Grand Tour as a finish to their education and came back with paintings and sculpture to decorate their stately homes. Art in England was greatly affected by this contact with Europe, and in particular, Italy.

Stubbs' stubbornly held view that a "direct-from-nature" approach to art was right for him, did not prevent him from wanting to see for himself why others felt it so necessary to study in Italy. So, in 1754, he set sail and was in Rome by Easter. His friend, the painter Ozias Humphry, who wrote the short *Memoir* of Stubbs, says:

> It does not appear that whilst he resided in Rome he ever copied one picture and so much had he devoted himself to observe and to imitate particular subjects in Nature that when ever he accompanied the students in Rome to view the Palaces of the Vatican etc., he always found himself differing from them in opinion upon the pictures.

Stubbs was down-to-earth and unimaginative and had a natural aversion to artificiality. The "Grand Manner" was not at all to his taste. His work was deeply considered and his designs carefully worked out, but behind it all was great simplicity plus an acute observation of all natural objects.

He only went "to convince himself that nature was, and always is, superior to art, whether Greek or Roman, and having received this conviction he immediately resolved upon returning home".

For the next couple of years Stubbs lived in Liverpool. He was becoming known and had many portrait commissions. Any artist recently back from Italy was sought after and considered to have special merit and he was no exception. His mother died during this period and once her affairs had been settled he left Liverpool. Possibly her death left him with sufficient money to complete the major project that he had first thought about in York. Of course, he may also have been making enough money from his portrait commissions to save a little. Anyway, he decided to go ahead with a period devoted to dissecting horses and making studies and drawings for the plates for his book *The Anatomy of the Horse*.

His first problem was to find suitable premises for his research. He decided on a village called Horkstow in North Lincolnshire. He had previously stayed at Horkstow when executing commissions for an early patron, Lady Nelthorpe, whose portrait with her husband he had painted in 1746.

Stubbs took a remote farmhouse, "that he might without inconvenience to others have dead horses, and subjects adapted to his purpose." For about sixteen months he worked on this enormous project. He needed to be well away from people so that the nauseating smells of decaying horseflesh could not reach the village. Other reasons could have been the (so called) disreputable nature of his researches. The dissection, even of horses, could have been looked upon as interfering with God's work and, therefore, be a devilish proceeding, so he had to be careful not to upset the

locals. It is hard to realise, in the 20th-century, just what a dangerous undertaking it was. Flesh without refrigeration or preservatives does not keep long, and it is said that he worked on one horse for eleven weeks. Single-handed, he had a long, heavy job just to prepare the horse and by the time he had got even the preliminary tasks completed, the animal must have been stinking. No effective disinfectants, flykillers or antiseptics were available and any slight cut on a finger could have caused him blood poisoning. Many anatomists came to a bad end in that way.

He had no helpers except for his "friend" Mary Spencer. It is a curious fact that Stubbs never married, yet he apparently lived with Mary Spencer for over forty years, and had children by her—his son George Townley Stubbs was born in 1756. She has been variously described as his "aunt", his "neice", and his "female friend", but she is generally accepted to have been his common-law wife.

Until Stubbs produced his anatomy, the standard work which every one based their equine information on was Carlo Ruini's *Dell' Anatomia et dell' Infirmita del Cavallo*, first published in 1598. Quite apart from the immense difference between the scientific accuracy of Stubbs' beautifully precise engravings and the stylised woodcuts of the 16th-century anatomy, the actual disposition and designs of the horses upon the pages was most carefully considered in relation to the shape of the book, so much so that they have an instant aesthetic appeal.

The work at Horkstow for the anatomy book can be divided into four distinct parts. First: the heavy job of bleeding the horse to death and rigging the dead animal in the work room-cum-studio, then stripping, disembowelling and injecting the emptied veins with waxes so that they would keep their shape. Second: dissecting carefully the parts that would give him the information needed for his notes and drawings. Third: making his drawings for the engravers to work from. Fourth: writing up the descriptions for the text of the book.

8

Humphry gave a detailed account of Stubbs' procedures:

As these studies and operations were singular and very important, the manner in which they were conducted may not be uninteresting to relate. The first subject which was prepared was a horse which was bled to death by the jugular vein,—after which the arteries and veins were injected. Then a bar of iron was suspended from the ceiling of the room, by a Teagle of Iron to which Iron Hooks were fixed.—Under this bar a plank was swung about eighteen inches wide, for the Horse's feet to rest upon, and the Horse was suspended to the Bar of Iron by the above mentioned Hooks which were fastened into the opposite side of the Horse to that which was intended to be designed; by passing the Hooks through the ribs and fastening them under the Backbone and by these means the Horse was fixed in the attitude which these prints represent and continued hanging in this posture six or seven weeks, or as long as they were fit for use.
His drawings of a skeleton were previously made—and then the operations upon this fix'd subject were thus begun. He first began by dissecting and designing the muscles of the abdomen—proceeding through five different layers of muscles till he came to the peritoneum and the pleura through which appeared the lungs and the Intestines—after which the Bowels were taken out and Cast away—Then he proceeded to dissect the Head, by first stripping off the Skin and after having cleaned and prepared the muscles and &. for the drawing, he made careful designs of them and with the explanation which usually employed him a whole day. Then he took off another layer of Muscles, which he prepared, designed and described, in the same manner as in the Book—and so he proceeded till he came to the Skeleton—It must be noted that by means of the Injections the muscles, the Blood-vessels and the Nerves retained their form to the Past without undergoing any

change of position—In this manner he advanced his work by stripping off the skin and cleaning and preparing as much of the subject as he concluded would employ a whole day to prepare design and describe, as above related till the whole subject was completed.

Of the drawings only 42 have survived from this period of intense scientific study. No doubt there were many more made over the years while Stubbs was researching the subject. He says in the preface to the book that he consulted "most of the treatises of reputation on the general subject of anatomy". He also said that the "Work was the Result of Many Years actual Dissections". However, the work at Horkstow was the culmination of his studies and researches. The drawings were left, with the rest of the contents of his studio, to Mary Spencer. When she died, in 1817, Colnaghi bought them. Eventually Sir Edwin Landseer acquired them by painting a picture for Colnaghi. He left them to his brother Charles Landseer, who was Keeper of the Royal Academy Schools for many years. Charles bequeathed them to the Royal Academy together with over £10,000 to found scholarships and prizes for the Academy students. The money is recorded in the Annual Report for 1879 but the drawings are not mentioned until the following year, when in the report of the Inspectors of Property, it is stated

.... that the Anatomical drawings of the Horse by George Stubbs A.R.A., be removed from their present position on the staircase leading to the Diploma Galleries and placed with his other works in the Library for the more convenient reference of the students.

It was probably at this point that a selection of 18 drawings were made—the more highly finished pencil drawings. In fact, those intended for the engraver to work from.

A solander case was made for the drawings so they could be shelved

with Stubbs' two books which were already in the library, *The Anatomy of the Horse* and the plates for *The Comparative Anatomy*. For nearly a hundred years these 18 drawings were thought to be the only ones, but in 1963 while going through a portfolio of 19th-century architectural drawings a parcel containing another 24 studies appeared. There is no record of the original number of drawings in the Landseer bequest but there is no reason to suppose that it was more than the 42 now in the Royal Academy library.

The drawings can be divided into two groups. Those that directly relate to the plates for the book are the most highly finished. The other group are working drawings made as Stubbs dissected each part of the horse. Many of them are really only notes, quite roughly scribbled in and bearing little resemblance to the plates.

Stubbs appears to have made a master-drawing of the skeleton and of the main outline of the horse. The master-drawing was traced onto numerous sheets of paper by means of pouncing—pricking tiny holes along the outline and then tapping powdered charcoal through the holes onto the paper beneath leaving a series of faint charcoal dots. These were joined up carefully in pale ink to give the exact outline of the master-drawing. In this way, Stubbs could achieve a continuity of size and pose during the dissection of a number of different horses. It is just possible to see these pale ink drawings with their faintly jerky line beneath quite a few of the studies.

Stubbs worked with a variety of media. The meticulous three-dimensional drawings made to engrave from, are all in pencil and are extremely beautiful. For example, the delicate precision with which he constructs a leg, showing bone, muscle and tendon, all with subtle differences of texture, gives great clarity and authority to the drawings and lifts them from just anatomical studies to drawings that give visual pleasure and are works of art in their own right.

The other studies vary considerably in method. Those that give the information in the diagrammatic outline engravings are in a kind of golden yellow ink with details of veins and nerves added in pencil and in black and sanguine chalk with the letters and figures in brown ink. There is a set of very frail and spidery looking measured drawings of the three views of the skeleton in sepia ink. The extremely delicate lines contrast with another drawing, much larger and very boldly drawn in heavy black ink.

There is a set of larger drawings, all in similar pose which do not relate at all to the book. The back and front views show the horse in steep perspective, giving a curious look to the animal. The head in the front view appears disproportionately large while in the back view the near hind leg seems unduly long. The reasons for the apparent lack of proportion can be explained by Stubbs having to work in very restricted space—right on top of a large subject instead of being a reasonable distance away. An 18th-century farmhouse is not an ideal studio in which to draw massive and unwieldly objects.

The drawings have a serenity, a calm and unemotional delicacy which is amazing when one considers the slaughterhouse atmosphere in which Stubbs must have worked. Perhaps not quite so extraordinary when one remembers that he was brought up more or less "over the shop" in his father's tannery and leather dressing business. Flayed animals and unpleasant smells were part of his childhood and presumably lessened the sense of revulsion associated with making drawings from putrifying remains in unventilated surroundings.

It is obvious that Stubbs had immense will-power and determination to carry through such a huge task single-handed. Not only did he have to be ingenious in coping with the great weight of a dead horse but he had to have the technical knowledge required for preparing the horse for dissection. He also had to do everything as quickly as possible before too much decomposition changed the shapes of the dissected parts. His

OPPOSITE PAGE

A drawing for the book *The Anatomy of the Horse*, published in 1766. 19" × 24".
Royal Academy of Arts

anatomical experiments were far more advanced scientifically than any-thing known previously, and his artistic skill in representing his researches was also far greater. Therefore, the final achievement of the book is its establishment as a landmark in the history of horse anatomy.

The Anatomy of the Horse is made up of 36 plates. There are 18 engravings; 6 front views, 6 back views and 6 side views. In each, there is an engraving of the skeleton and 5 plates of the muscular layers progressing from the subcutaneous to the bones. These are the fully modelled illustrations showing the horse with sculptural definition. They are paired with 18 line engravings of the same views and anatomical layers. These are lettered and numbered for easy reference to the text. By having separate illustrations for this it avoids spoiling the full engravings with any kind of key spotted over their surface.

This arrangement appears in the book by Albinus published in 1747, *Tables of the Skeleton and Muscles of the Human Body*, the English edition appearing two years later. Stubbs would certainly have used this during his studies of human anatomy. However, Albinus' anatomised men, engraved by Jan Wandelaar, are shown in elaborate settings, dramatically lit with additions in the background of ruins and exotic animals. Stubbs' plates are quite simple in comparison. The horse is shown as a monumental shape beautifully designed in the space available on the page. The simplicity of the design and the solidity of form allied to an authoritative accuracy is extremely powerful. Stubbs had hoped to have his drawings professionally engraved but he had the same problem as with the Midwifery book. The engravers did not care to be associated with the subject. He brought the drawings to London in the autumn of 1759 and approached many of the better known engravers, but they were not interested. So, undaunted, he set about engraving the plates himself.

In the eight years which had elapsed since the publication of his illustrations for Dr. Burton's book Stubbs had matured and developed both

technically and aesthetically. His analysis of form and his draughtsman-ship were by now masterly and he had no difficulty in translating his beautifully observed sensitive drawings into engravings of great direct-ness and accuracy. The work of producing these plates for the book took him nearly six years. But, of course, he was by now a busy painter with many commissions from important clients, so the anatomical plates could only be worked on in the evenings when the light had faded too much to continue painting.

It is always said that it was the publication of *The Anatomy of the Horse* which brought Stubbs so many commissions to paint horses and, of course, it did bring his name to a much wider public. However, it is probable that in order to find an engraver willing to complete the plates, he came to London from the North to look for one. He settled in Somerset Street at number 24 and remained there for the rest of his life. This house and the whole street has been swallowed up by the extensions to Self-ridges, who commemorated it by two bronze plaques on the walls of the book department. His studio, which he called his "Exhibition room" was built out at the back of number 24 on the gardens. It was large enough to accommodate a horse as a model and had plenty of room for him to complete his great life-size paintings of Whistlejacket and Hambletonian. There too he had the space for his anatomical experiments and his engrav-ing equipment. The studio, at the end of his life, must have been full of studies and drawings of his different activities. In the studio sale following his death there were many portfolios of studies listed—landscapes, lions and tigers and all sorts of things. It is worth noting that the only drawings that seem to have survived are the anatomical studies and they seem to have been preserved more for their information than for their artistic value. It is sad that out of about 600 drawings mentioned in 1807 so few are known.

The Anatomy of the Horse was published on Saturday, March 1st, 1766. It

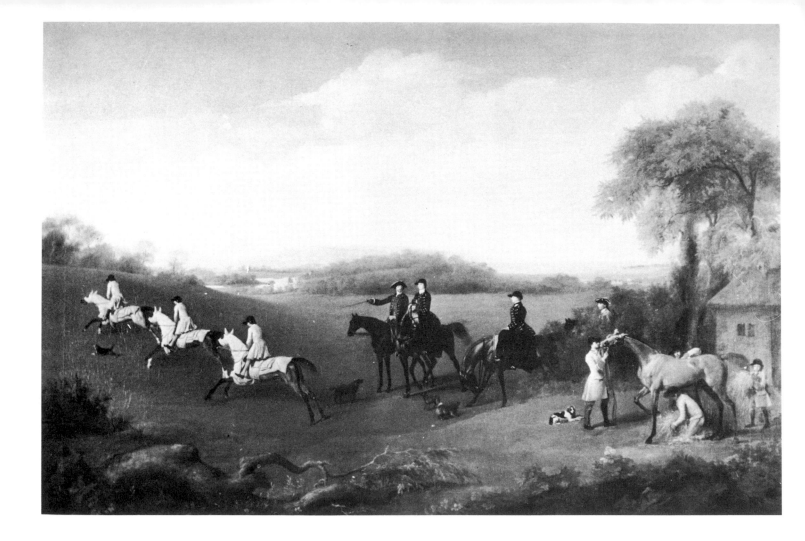

was priced at 5 guineas—probably too high a price for "Farriers and Horse doctors etc." to buy, but no doubt the "Gentlemen who breed horses" were well pleased with their 5 guineas worth and certainly generations of artists ever since have been greatly helped in their understanding of the structure of the horse.

Except for the year of intense dissection at Horkstow all the work on the book was carried out at the close of Stubbs' normal working day—or rather, painting day. He never used daylight hours for his anatomical work if the light was good enough to paint by. In fact, the 1760s were some of his most productive and busy years with commissions from many influential patrons. For about nine months he stayed at Goodwood painting a number of large hunting, shooting and racing subjects for the Duke of Richmond. He had by now established a reputation as a painter of animals, particularly, of course, of horses. His capacity for work was tremendous—most of the canvases were large, some, like the life-size portrait of Whistlejacket, were huge. Another important work of this period was the big painting of the Grosvenor Hunt. It is a particularly interesting design. The stag has been brought down in a stream under a tree, whose curving trunk circles the group of horsemen standing watching the hounds attack. The actions of the hounds has been beautifully observed as they leap from the bank into the water. The rhythmic lines of the pack draw the eye to the important part of the composition. All the participants of the drama face left except for the dominant figure of the huntsman with his horn standing on the left bank. He holds the composition together and by his majestic pose he returns the eye to the centre of the design.

It was in the 1760s, when so much was happening for Stubbs, that he first became interested in painting mares with their foals in various permutations, mostly in shallow lateral groups on horizontal canvases. These frieze-like designs are some of Stubbs' best known and most loved works.

OPPOSITE PAGE

"The Grosvenor Hunt". 59" × 95".
Private Collection

18

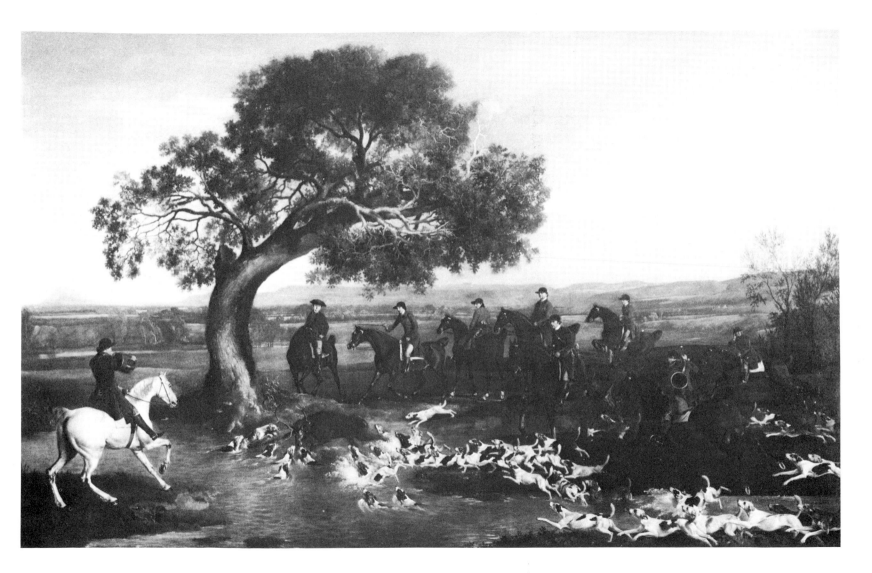

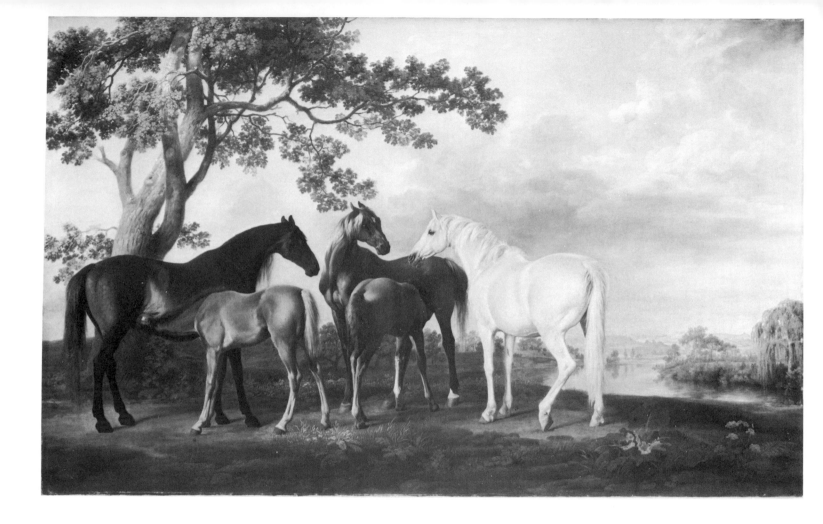

"Mares and Foals in a Landscape".
39″ × 62½″. *Tate Gallery*

"Mares and Foals". 40″ × 75″.
 Private Collection

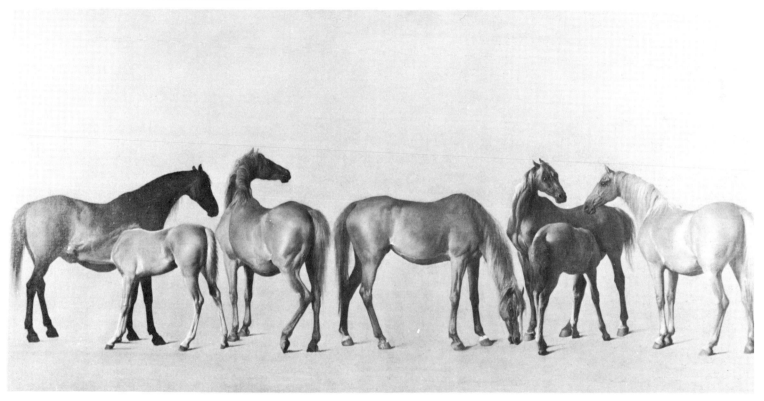

Individual groups and single mares appear in more than one painting. Stubbs used the same studies for a number of works. For all his devotion to "working direct from nature" it is more likely that his original drawings and studies were directly from nature but that the finished paintings were produced in his studio. He seems to have completely finished the horses first on a blank canvas and then painstakingly fitted in a landscape background around them. This method of working needs a very precise judgement of tone. There is one painting of this theme which has no landscape background at all. Of all the dozen or so paintings of mares and foals this is the most beautifully constructed design. The interplay of curved and straight lines and of sculpturally solid forms are superbly realised. The seven animals are in two groups linked by a grazing filly in the centre. The two groups of mares and foals are repeated in the Tate Gallery's painting and Stubbs obviously used the same study for the right-hand mare. In both paintings her neck joins her withers in a very curious fashion though the actual composition with the lines of the back and the swirling up-curves of the necks is very happy. The design manages to contend with 28 legs and arrange them so that they make a wonderful pattern of vertical and diagonal lines with an occasional sharp angle created by a relaxed hock.

The other great painting without a background is that of the palamino stallion Whistlejacket, a regal and magnificent life-size portrait. It was originally intended that it should be a royal portrait, the king mounted on a superb charger against a landscape background. Stubbs was commissioned to paint just the horse, a well-known landscape painter was to do the background and a fashionable portrait painter was to paint the king. A somewhat doubtful arrangement aesthetically! Legend says that Stubbs had practically completed the huge painting when he decided to take the canvas off the easel and prop it against the stable wall—no doubt to view the horse and the painting together from a different angle and in a

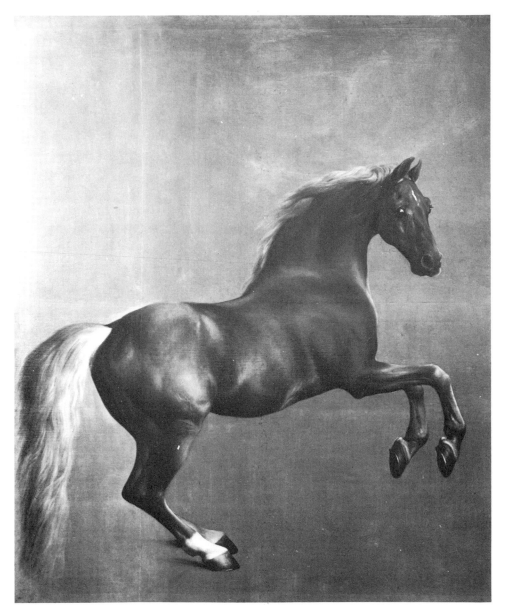

"Whistlejacket". 10′ 8″ × 8′ 6″.
Private Collection

different light. However, for the very first time, Whistlejacket, who had a difficult temperament, caught sight of his portrait. He immediately took it to be a rival stallion and attacked it! He reared up swinging the lad who was leading him completely off his feet, and struck out at the canvas with his front hooves. Stubbs is said to "have pummelled the horse with palette and maulstick". Luckily, as soon as they managed to distract and turn Whistlejacket away from the painting he became manageable and all was well. Miraculously the canvas escaped damage. When Whistlejacket's owner, the Marquis of Rockingham, heard of the episode he refused to allow anything more to be done to the portrait and kept it as it is, a tribute to a great horse and to a monumental painting.

The frieze of Mares and Foals theme continued to intrigue Stubbs for about ten years. After that he moved on to other problems of design and subject, this, of course, in addition to his commissioned horse portraits and his anatomical experiments and studies.

The second theme to occupy him was that of the Lion and Horse and is said to have come from a visit to Morocco made by Stubbs on his way back from Italy when he saw a lion actually attacking a horse. However, neither Ozias Humphry nor Mary Spencer refer to this incident though there is a detailed account of Stubbs making studies of Lord Shelbourne's lion. Also the first of the long series was not exhibited until 1763, nearly ten years after his Italian trip. There are four different episodes in the dramatic sequence. First the startled horse sees a distant lion stalking him. In the second version the lion has closed in on his prey and the third in the series shows the lion having sprung onto the horse's back gripping its withers with his teeth. Fourthly the horse has collapsed under the lion.

Stubbs painted the Lion and Horse theme in numerous different forms. He used a wide variety of mediums from oil to mezzotint and including enamel on copper and on ceramic plaques. He even modelled it in low relief. He worked in an equally wide variety of sizes from a few inches in

OPPOSITE PAGE

"Horse devoured by Lion". $27\frac{1}{4}" \times 40\frac{1}{4}"$.
Tate Gallery

24

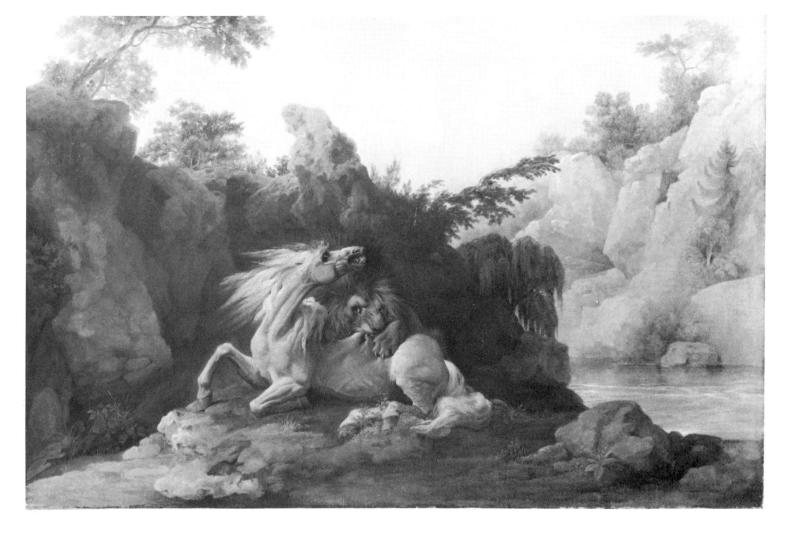

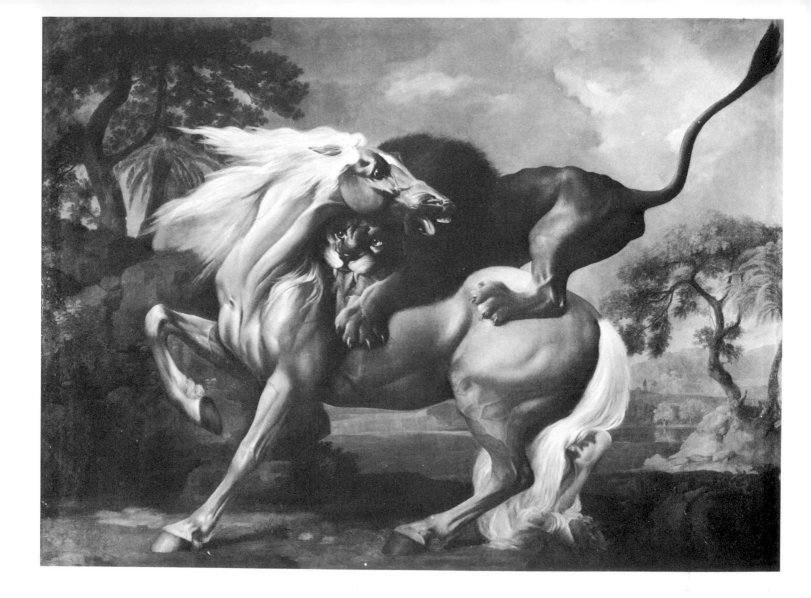

diameter in enamel to life-size versions on canvas—such as the version now in the Mellon Collection.

In this, the lion has just leapt on to the horse's back, his tail stretched out towards the upper corner of the canvas. The diagonal is strongly marked by this and by the standing foreleg of the horse. The other corner to corner diagonal can be detected by the edge of the background tree, the line of the horse's head and running through the silhouette of the dropped quarters. The weight of the lion is supported by the solidity of the full tail as well as the hefty hocks and quarters. The group makes a very powerful design with a tremendously sculptural quality. The other versions do not have the same affinity to classical sculpture—which of course Stubbs could have seen on his Italian trip or he could have seen the Scheemaker group in the garden at Rousham when he was painting there. Stubbs continued to produce variations on the Lion and Horse theme over a long period.

It is very difficult to say much about Stubbs' activities outside his work. There is so little to go on. However, when the Society of Artists (which was the first society to hold exhibitions of paintings in England) was formed, he exhibited with them from 1761. In 1765 he was elected a Fellow and only a few days after that a vacancy occurred among the twenty Directors. Five painters were proposed and Stubbs was the one chosen. In 1768 William Chambers was the society Treasurer but he was busy negotiating with others to found "The Royal Academy". Once the rival institution seemed certain to have Royal approval he resigned. A few days later, Stubbs, who had not joined the mass exodus in favour of the R.A., was elected Treasurer. He continued to hold this office for nearly four years. It must have been quite time consuming. He had not only to keep account of all money received or spent by the society, but also to help hang the exhibition and to attend every day during the period when it was open. The society decided in that year to open their own Art School in rented premises. They were trying not to lag behind the Royal Academy who had based their

OPPOSITE PAGE

"Lion and Horse". 96" × 131".
 Mellon Collection

27

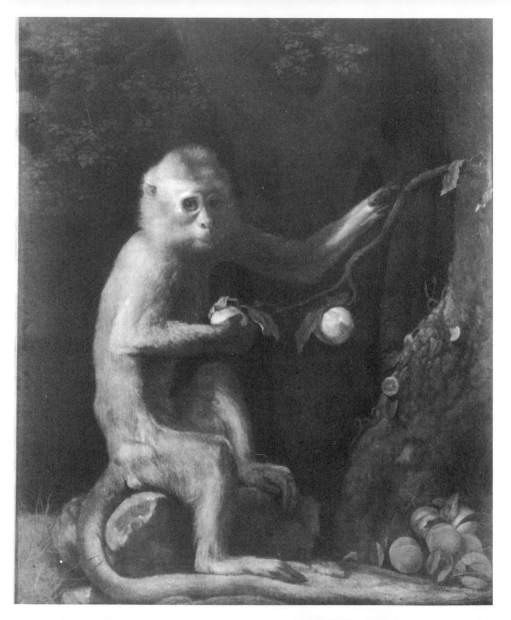

Though known primarily as a horse painter, Stubbs also produced many canvases of other animals.
"A Monkey". $27\frac{1}{2}" \times 22"$.
Merseyside County Art Gallery

institution on a free School of Design. Stubbs was one of the six members who "set the model and presided over the school to maintain 'decorum'". Once they had achieved a school they set about buying land and building a gallery. This took all their capital and they ended up having to borrow money to keep going. A worrying time for any Treasurer. The gallery was opened in 1772 and in that year Stubbs was released from his tiresome job and elected President of the Society of Artists. At the end of a year he was back as a Director and by 1775 he ceased to exhibit. He had given up a lot of time to keep the society going, but now it was obvious that the Royal Academy was indisputably the premier institution showing work by all the foremost artists. It was in his own interests to exhibit with them. His friend and biographer Ozias Humphry said that "the interruptions which these Offices gave to his professional studies and domestic repose were always considered by him as a great evil, and produced in him a desire to withdraw from all academical associations". His association with the Royal Academy was not entirely happy. It was five years before his name appeared on the list of candidates for election as an Associate Member. He attended a council meeting in February, 1781, to be "introduced by the Secretary" and to have the Instrument of the Institution read to him. This document told him of the obligation of all full members of the Royal Academy—"Royal Academicians" or "R.A.'s"—to present an example of their work to the institution before their Diploma could be signed by the sovereign. When, only a few days later, there was a General Assembly to elect an Academician, Stubbs was elected. There could be no question of him being unaware of the rule that members had to give a work within a year of election, yet this is supposed to be the reason why he fell out with the R.A. Humphry says that Stubbs felt that the rule had been brought in against him in particular. There is no way of clearing up the mystery of Stubbs' huff with the R.A., but it seems likely that he might have offered one of his enamel paintings on ceramic plaques as his "Diploma" picture

and that the council refused to accept it. He was said to be hurt by the poor hanging of his enamels in the exhibition and there was eventually a rule forbidding the submission of such works for exhibition. Certainly the result of these misunderstandings between him and the council led to the fact that he never did give a Diploma work, and, though properly elected an Academician his Diploma was never signed by the king and he was never entitled to use R.A. after his name.

The Royal Academy, unfortunately, lost what would, no doubt, have been one of the most valuable of their collection of Diploma works through this muddle.

Stubbs' interest in enamel painting began late in the 1760s. It was a curious diversion in that he was a successful painter in oils and could have had little time to experiment with a new and complex craft or hobby. His neighbour, Richard Cosway, R.A. had painted tiny works in enamels so it is possible that Stubbs started fiddling around with copper plates left in his studio from his engravings to see if he could produce something bigger and better. But why bother? It was a far more awkward process than painting in oils and had really only been used for decorating small objects such as snuff boxes by skilled craftsmen rather than by acknowledged artists. How did he learn the techniques involved? One can only assume that Cosway may have passed on advice that was sufficient for Stubbs to start experimenting on his own. He could perhaps have gone to one of the factories in the Midlands, like Bilston, to learn the craft, but there is no record of this.

The process of painting in enamel begins with an opaque white ground being laid on the copper plate which is then fired. On this white base the design or subject is painted with gouache-like colours. The whole has to be fired again to fuse the painted surface to the white flux. The control of temperature within the kilm has to be extremely precise to prevent imperfect fusion of the pigments. Did Stubbs acquire copper plates ready pre-

pared with white enamel flux and did he send his paintings to be fired or did he undertake the whole procedure himself? The most interesting question is "Why?" Why did he feel the urge to try a new medium? It was not a novelty, the Egyptians had used it for decoration, nor was it an accepted method for serious artists. Perhaps the answer lies in its permanence. Stubbs may have felt that enamels are less changed by darkening and cracking than oils. Certainly the enamels have suffered less from over-enthusiastic cleaning than some of his paintings. But, of course, he worked on fragile ceramic plaques which were vulnerable to breakage. Humphry says that he made many chemical experiments to obtain a set of pigments that did not change colour during firing—in all nineteen different tints. One of the problems, from Stubbs' point of view, was the restriction on size when working on copper plates instead of canvas or panels. As the size grows the danger of warping grows and to combat this the plate has to increase in thickness and therefore becomes too heavy. His earliest works are on copper, mostly octagonal in shape and about 10" in diameter. The surface of these small paintings is glassy, with an almost jewel-like shine. Stubbs tried various subjects, portraits and wild animals but for a painter used to tackling life-size paintings of horses these almost miniature works did not satisfy him. Humphry says "their dimensions not reaching the wishes and conceptions of Mr. Stubbs, he made application to the Potteries and Artificial Stone manufacturers." Eventually Josiah Wedgwood agreed to try and produce large flat plaques of biscuit earthware. So, at the end of the 1770s Stubbs began to work on Wedgwood tablets which must have entailed a good deal more experimenting as the firing temperature would have been lower than that used for copper and would have affected his colours. It was also a problem for Wedgwood to fire successfully large flat panels without cracking or warping them. Most of the larger enamels on ceramic bases are oval in shape, probably to avoid warping. The finished painted surface is matt, not highly-glazed as are the

copper-based paintings. It was their clear light tones that earned their poor placing in the Royal Academy. Other members' works must have looked very different under their fashionable coats of heavy golden varnish. On the whole, the paintings on pottery panels seem to have been less popular than the oils as there were a number of unsold works left in Stubbs' studio after his death. His connection with Wedgwood came at a period in his life when he had established himself as a renowned painter of animals. Unfortunately, the animal painter came very low in the pecking order of artists. The taste of the time, influenced by the French Academy founded in the 17th-century considered that the history painter had the highest aesthetic importance followed by the portrait painter and way down below them came the landscape and the animal painters—so far below the other two that they were barely "Fine Art" and were nearer to the signpainter. The inclusion of "vulgar beasts" into pictures was *not* recommended. Stubbs, having become typecast as a "horse painter" felt this distinction prevented him from taking his place among the top painters of the day. However excellent his work, it was passed over as "mere" animal painting. He wanted to change his image and prove that he could undertake both history and face painting. He was not really interested in historical or mythological subjects. His powers of invention and imagination were not as highly developed as his powers of observation and design. He was not well suited to illustrating a dramatic or "heroick" story in the "Grand Manner". He disliked anything artificial and, therefore, these subjects were in opposition to his desire to paint directly from nature. The category that would have suited him was that of the "face painter". In fact, everything he painted was a portrait—even though the subject was a foxhound or a foxglove.

Stubbs' attempts to change his reputation proved an impossible task. The critic Peter Pindar wrote:

'Tis said that naught so much the temper rubs,
Of that ingenious artist Mr Stubbs,
As calling him a horse-painter—how strange,
That Stubbs the title should desire to change . . .

and another "Ode" went

. . . . Let modern artists match thee, if they can
Such animals thy genius suit
Then stick, I beg thee, to the Brute,
And meddle not with Woman, nor with Man.

It was a great disappointment to Stubbs that the public refused to accept him as anything but a horse painter.

He stayed at Etruria with Wedgwood in the 1780s when the ceramic tablets were being experimented with and painted various portraits for the family. Wedgwood wrote that he hoped that these portraits would

. . . . give him a character which is entirely new to him, for nobody suspects Mr Stubbs of painting anything but horses and lions, dogs and tigers, and I can scarcely make anyone believe that he ever attempted a human figure. Indeed Mr Stubbs resents much his having established this character for himself, and wishes to be considered a history and portrait painter.

Stubbs and his work suffered from the low opinion of the animal artist until the middle of the 20th-century. Now, at last, his paintings are properly appreciated as a major contribution to European Art. If he had been able to become fashionable as a portrait painter, would he have rivalled Gainsborough and Reynolds? His uncompromising attitude to nature might have prevented the slight flattery which encouraged

prospective sitters. However, a study of the few portraits known and those that appear in a secondary position holding horses etc., give a clear indication that had he had the opportunity he could have become a serious challenger. There are some delightful small heads in his conversation pieces. Stubbs' penetrating eye catches the stance and character of grooms and trainers as well as those of the gentlemen who rode horses. The painting of the celebrated little racehorse Gimcrack has two such portraits. The solidly standing trainer who not only holds the exhausted horse but also holds in the whole design: the action of which travels across the canvas from right to left, and his lad kneeling by the horse is a beautifully observed little figure. Among the few female portraits in a rather unflattering one of Sarah Wedgwood in enamel on a ceramic tablet. As usual, his highly developed sense of design has made the most of the shapes of her interesting headdress and hair style. The whole head and shoulders are perfectly placed in relation to the oval shape to be filled. The portrait "A Lady reading in a Wooded Landscape" is graceful and charming with the delicately embroidered flowers on her gown and with real flowers at her feet and twined around the garden seat. The composition is interesting in the way it uses the triangular shapes, first her whole figure making a triangle of light which is echoed by the shape of the trunk and branches of the tree immediately behind her.

Stubbs' self portrait is in the National Portrait Gallery. He portrays himself brush in hand—and a surprisingly delicate hand for a man who heaved carcases of horses around without help. He looks determined yet slightly shy. There is a careful squared up drawing for this enamel painting that gives an insight into his working methods. Nothing slapdash or left to chance, everything carefully planned and designed. He also painted himself, again in enamel, on a grey horse against a dark wooded background sitting back looking relaxed with his hand in his pocket. Once again fitting into the inevitable oval of the earthenware plaques.

34

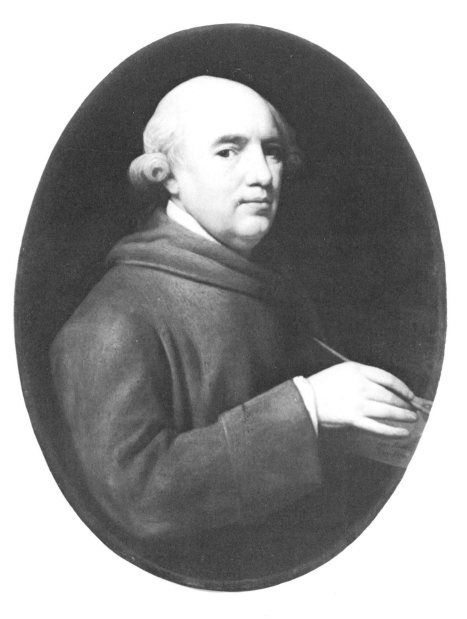

Self Portrait. 27″ × 20″.
National Portrait Gallery, London

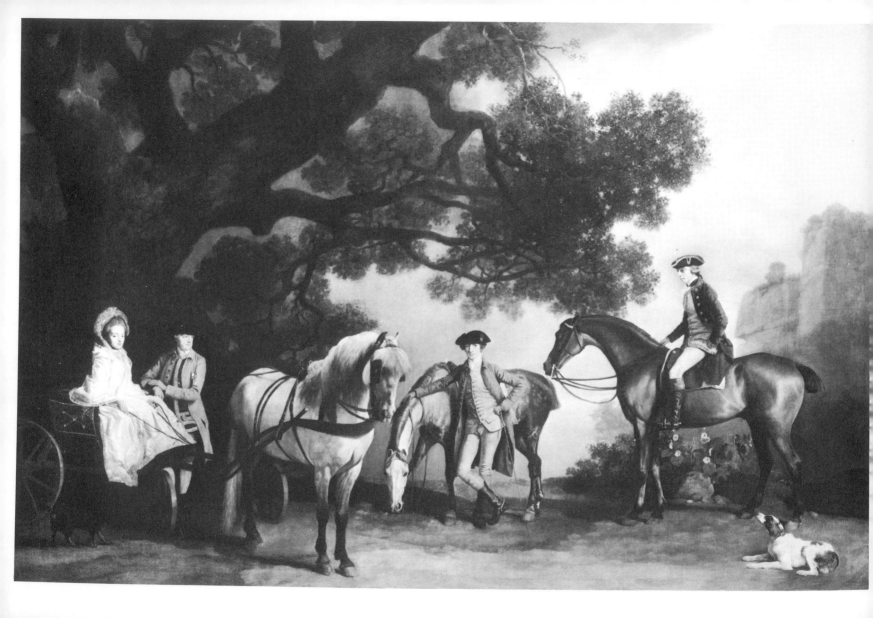

Some of his most delightful compositions are his conversation pieces, for example the painting of "The Melbourne and Milbanke Families", shows Lady Melbourne parked in her pony cart under a huge tree beside a lake and the same setting appears again in "Colonel Pocklington and his sisters. (This painting is now in the National Gallery of Washington.)

Both these paintings have an elegant informality and restrained colouring. Stubbs' colour sense was subtle, he prefered quiet colours with a gentle tranquillity about them. They were mainly grey blues, pale misty greens, stone colours and browns but almost always there is a note of sharp contrast—the delicate pink of Lady Melbourne's dress, a flame coloured jacket or bright golden ochre breeches pick up the paintings and avoid them being too monochromatic. In the painting of the Prince of Wales' Phaeton, Stubbs has limited himself to black, white and pale vermillion set in one of his favourite misty landscapes by a lake. He shows the black phaeton picked out in red, the magnificent pair of carriage horses black with white hind socks and red rosettes, the black and white dog and the portly coachman dressed in black and white with a red coat. Everything carefully chosen and matching but to avoid the painting becoming over stylised in colour he has introduced the patch of bright yellow of the groom's breeches.

Stubbs made a number of paintings for the Prince of Wales in the 1790s, including a portrait of him trotting briskly along in the park. His horse is more satisfactory than he is. He unfortunately suffers from rather curious proportions. Stubbs has a habit of giving his figures small heads, hands and feet. This style became fashionable in early Victorian times, but in Stubbs' paintings this is hardly likely to be the reason. It gives a puppet-like look—could Stubbs have intended this as a commentary on the sitter? He surely had his tongue in his cheek when he painted "The Soldiers of the Tenth Light Dragoons". The neat row of toy-like soldiers being inspected by a corporal with drawn sword mounted on a majestic charger,

37

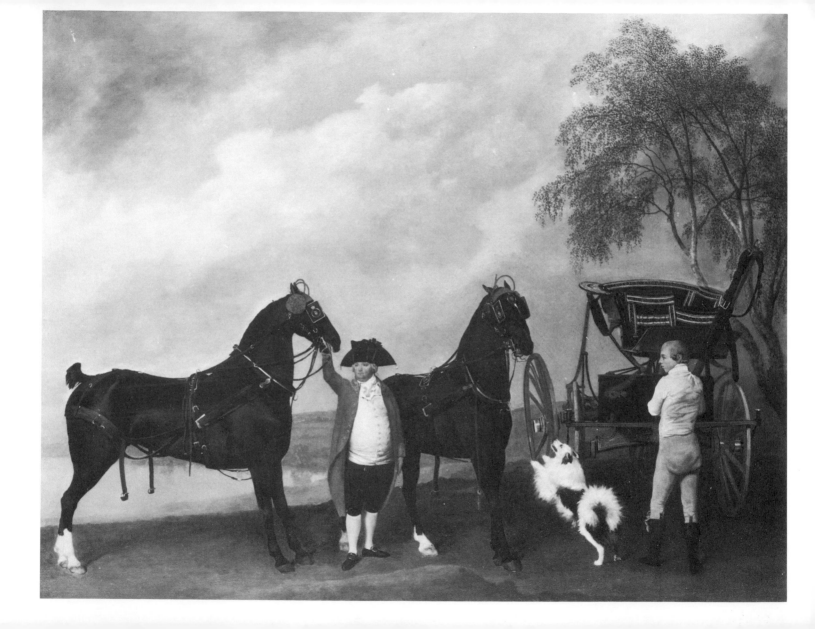

OPPOSITE PAGE

"The Prince of Wales' Phaeton".
$40\frac{3}{8}'' \times 50\frac{1}{2}''$. *Royal Collection*

"Soldiers of the Tenth Light Dragoons".
$40\frac{1}{4}'' \times 50\frac{3}{8}''$. *Royal Collection*

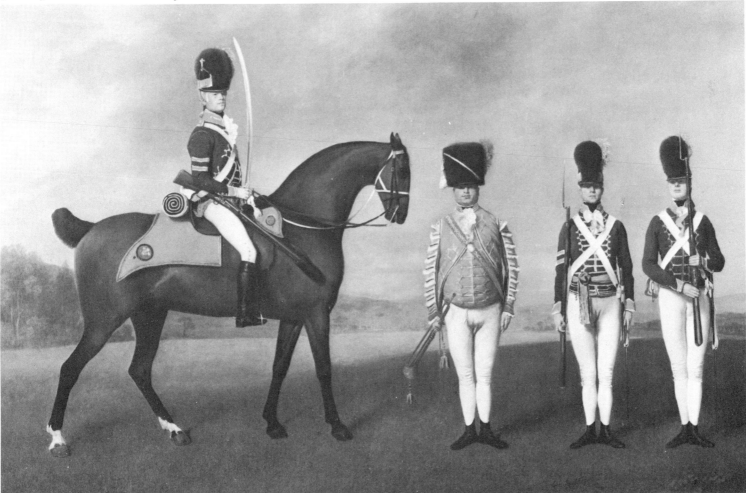

all rigidly to attention and very dignified and pompous, must have been intended as a humorous comment on military precision. The "Lady and Gentleman in a Carriage" (now in the National Gallery) have been given a decidedly smug air, they are both so obviously pleased with their turn-out that one feels that they have done very well for themselves and have spent a lot on their carriage and pair. Did Stubbs intend to convey this idea or did it creep in unnoticed?

The delightful group in the Holburne of Menstrie Museum of Art, Bath is treated more sympathetically. They are not nearly as self-conscious and the horses are painted with affectionate observation. The Rev. Carter-Thelwell's stout little cob and the pony that Mrs. Carter-Thelwell is driving are character studies in their own right. Their coats and tack are painted in the most masterly fashion, minutely recorded. Stubbs' acute sense of tone makes it possible for him to paint the dull sheen of well kept black leather against the living shine of a well groomed black horse and make it a visual joy. His ability to see the underlying form and structure of animals is second to none. His anatomical studies gave him this authority but he never allows it to detract from the superficial simplicity of the animal.

Three of Stubbs' more interesting clients were Sir Joseph Banks and the Hunter brothers, William, who became the first Professor of Anatomy to the Royal Academy, and John, also a surgeon. John Hunter was a collector of specimens of all kinds of animals. He kept a zoo in Earls Court and had a vast scientific collection in Lincolns Inn Fields, and was said to have dissected over 500 different animals.

Stubbs was commissioned by the Hunter brothers to paint various species in the 1770s. It is likely that he would have gone to their public lectures and might have been able to get a ticket for William's Royal Academy lectures. Reynolds was said to sleep through them but Stubbs would have been extremely interested. For John Hunter he painted the famous rhinoceros that was exhibited all over Europe. It was shown at

OPPOSITE PAGE

"Lady and Gentleman in a Carriage".
$32\frac{1}{2}$" × 40". *National Gallery, London*

40

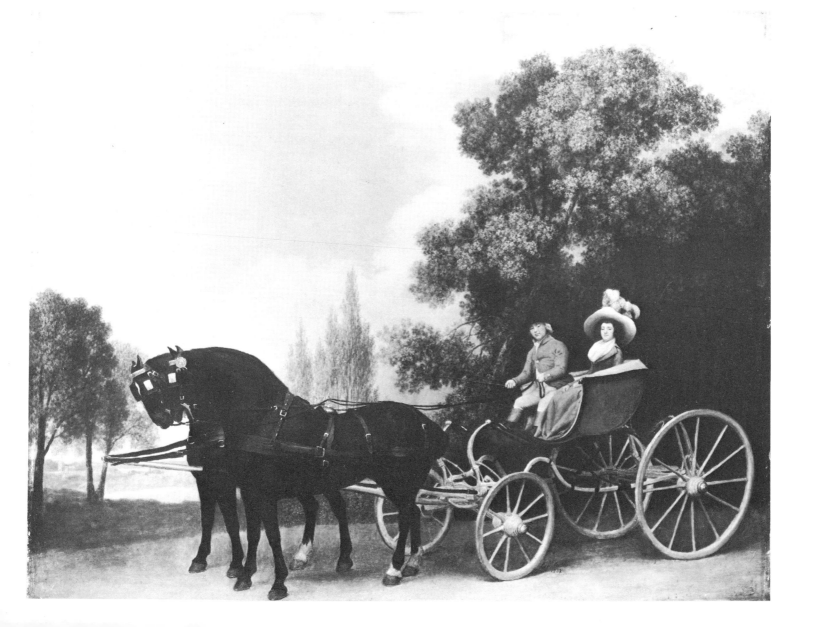

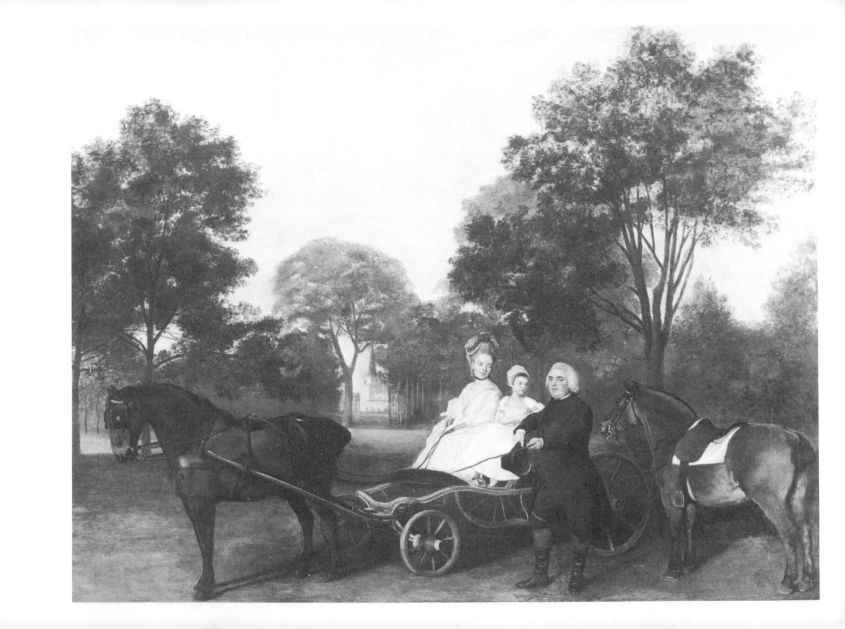

Pidcock's Menageries in 1772. Nine studies of it were sold during the sale of Stubbs' effects. It was at Pidcocks that a tiger died and Stubbs was informed at 10 o'clock one evening that the body could be had for a small sum. He dashed off and for 3 guineas he was able to purchase the tiger's remains. He spent the rest of the night "carbonading" it in "the place set apart for his muscular pursuits". It was probably contact with the Hunters that inspired his desire to carry on with his anatomical work and eventually produce *The Comparative Anatomy*. One subject was to be the tiger and the others for comparison were the common fowl, or chicken, and the human. But that did not start seriously for another twenty years.

For Sir Joseph Banks, who accompanied Captain Cook on his voyage in the *Endeavour*, Stubbs reconstructed a kangaroo from the skin brought back from the expedition.

One of the most beautiful of his wild animal portraits is that of the cheetah, brought back by Lord Pigot, Governor of Madras, for George III. A stag hunt was arranged in Windsor Park so that the cheetah could show off its hunting ability but so many people came to watch that it could not be persuaded to hunt at all. Stubbs painted it with its Indian handlers. The portrait is wonderfully observed. Stubbs' structural appreciation and his delight in the spotted furry coat come together to express exactly a beautiful hunting animal built for speed and strength about to be released. The portraits of the Indian servants are also interesting. The stag, which was at one time painted out, is not so happy and the landscape is not convincing as either India or Windsor Park but it makes a good solid background to the figures. Twenty years later Stubbs made a mezzotint of a sleeping cheetah though the muscular strength is not so apparent in this relaxed portrait. His interest is more in the soft velvety quality of the spotted coat.

Stubbs was never really considered seriously as a printmaker although a number of other people engraved his pictures, and are recorded in lists of engravers. His son George Townley Stubbs engraved his father's work,

43

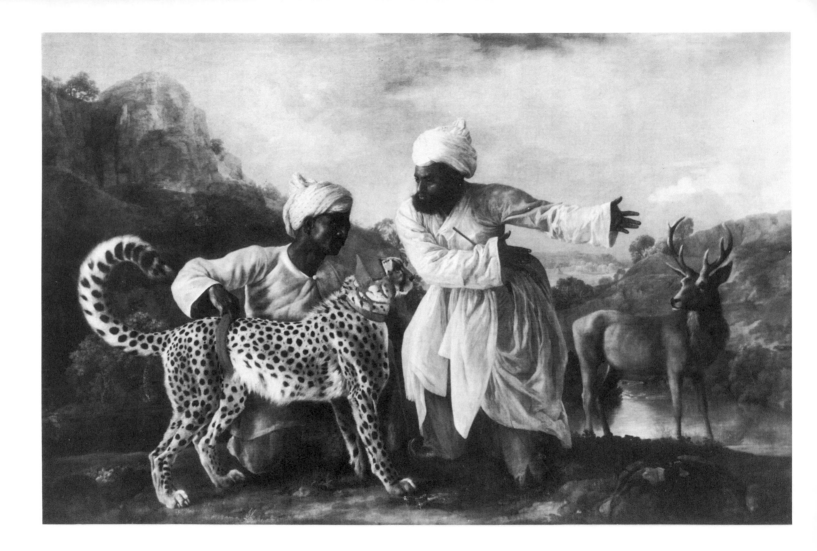

particularly that for *The Turf Review*. However Stubbs was concerned with engraving from early on in his career. He was somewhat forced into it by lack of response from professional engravers over, first the Midwifery book, and then *The Anatomy of the Horse*. But once these illustrations were safely published he seems to have left a gap of ten years or so before more engraved work appeared. In September, 1777, he published the first of his engraved "pictures", a version of his Horse frightened by a Lion series. This was an etching with some engraving. In all, he engraved some 18 plates, mostly published in 1788. These ranged in subject from small plates of lions, cheetahs and hounds to quite large versions of his rural scenes. For these, he pushed all etching techniques to the limit. He experimented with every kind of texture; etching, engraving, stippling and mezzotinting, to produce the richness and subtlety of tone and soft gradations from palest silvery greys to deepest blacks. His final plate, not counting *The Comparative Anatomy* illustrations, was published in 1804. This was a mezzotint of the painting of Freeman, Keeper to the Earl of Clarendon with hound and doe.

Like his excursions in enamel painting it is intriguing to speculate on why he bothered. Undoubtedly it would have been a loss to posterity if he had not embarked on engraving subjects of this kind as well as his scientific illustrations. Was it a form of advertisement? After all, engravings reach a wider public. Was he hard up and hoped they would bring in some ready money? This is probably partly true. Great patrons are not noted for paying their bills promptly. It is also possible that he enjoyed trying his hand at something different and also he readvertised with these plates *The Anatomy of the Horse*, published twenty years previously. He may have felt that there was a permanence about prints, less easily changed by time, and that an edition of prints are more likely to survive than one single work. One of his most successful was "Labourers", a large 20" × 27" print. Executed in mixed methods it shows a group of farmworkers arguing as to

45

how to put back the tailpiece of a cart. It is based on the earlier painting exhibited at the Royal Academy in 1779, but, like all his engravings, it is not a mere reproduction of a painting, it stands in its own right as a truly creative work.

The subject of the labourers painted for Lord Torrington at Southill, was the start of what might be described as the third of Stubbs' themes. He had painted his Mares and Foals theme out of his system and did not return to it. The Lion and Horse theme was still interesting him on and off, but now he began a series of farming subjects.

Rustic subjects were fashionable at this period. Many painters did well with slightly idealised and sentimental scenes of "simple peasants" in picturesque landscape settings. Stubbs' rural scenes have no sentimentality, they are beautifully designed and carefully observed from nature as would be expected from his independent attitude. There are no dead trees, fake ruins or broken down walls so loved by the romantics of the time. His farm workers are sturdy people going about their work, not actors in a contrived scene.

A study of one of Stubbs' main subjects "The Haymakers" is particularly interesting as it demonstrates clearly his intense preoccupation with design and composition. The first time he painted this, in 1783, he gave it a rather austere simplicity, tinged with sadness. The evening mist has turned the blue summer sky to palest rose, the haymakers are working late gathering in the last load. The hay cart and horses are silhouetted against the sky facing a dark and solid clump of trees. Two women scratch up the remains of the hay while the two men load on top of the cart.

Two years later he paints it again. It is earlier in the day, the cart is not so full, there are now three women and four men working. The whole composition is designed to balance with its pair, "The Reapers". The canvas divides in half diagonally with all the weight of tone and of action in the left hand lower half while the right portion contains little but sky and

the leading horse. The centre of the picture is held by the man and his pitchfork on top of the hay and by the woman who stands looking at the painter. The group has been designed to fit into a triangular pattern, the sloping lines of the rakes leading the eye up to the centre of the picture where it meets the line created by the edges of the trees and down through the horse's ears to the darker tones of the horizontal of the middle distance.

Stubbs used the same idea yet again nearly ten years later when he painted it in enamel and redesigned the component parts to fit on to one of his oval tablets. Each time he improves his structural organisation within the frame and this is so with the three companion pieces of "The Reapers". He painted another enamel of cutting the hay of which the central figure is the same standing woman holding her pitchfork upright that appears in the three other Haymaking pictures.

As well as the farming subjects there is one which, though it is of a farmer's wife riding to market, is really an attempt to illustrate the John Gay table of the Farmer's Wife and the Raven. The group has a sculptural quality that make it seem a trifle stylised but the design as a whole comes off extremely well. Stubbs painted it both in enamel and in oils. He alters the design slightly to compensate for the oval shape by introducing a line of fencing to stabilise the composition. The oil paintings of rural subjects were executed in the late 1780s and the enamels about ten years later.

In 1790, the sporting magazine *The Turf Review* made an offer to Stubbs which, as his commissions were not then as numerous as they had been, must have been very welcome. They intended to publish a collection of prints of all racehorses of note, from 1750, starting with the Godolphin Arabian, together with their pedigrees and performances. There were to be 145 prints after paintings done by Stubbs "at immense expense and solely for this work". He was to receive £9,000 presumably for 145 paintings, which works out at a little over £60 each. Not "immense"

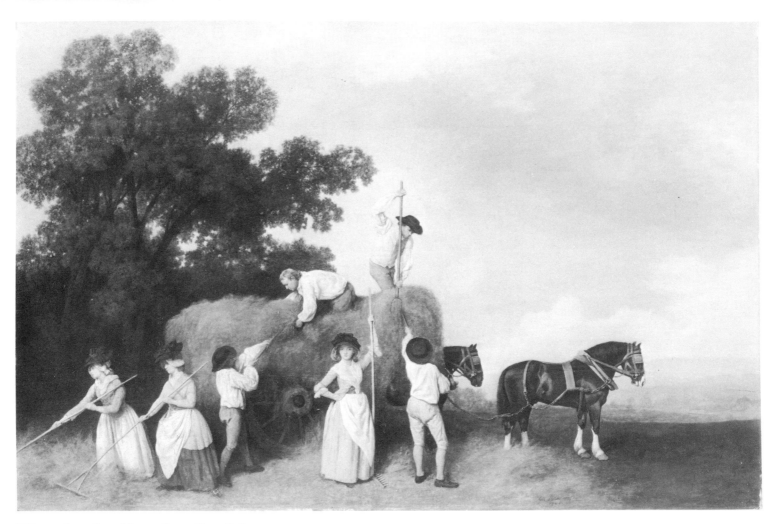

''Haymakers''. 35½" × 54". *Tate Gallery*

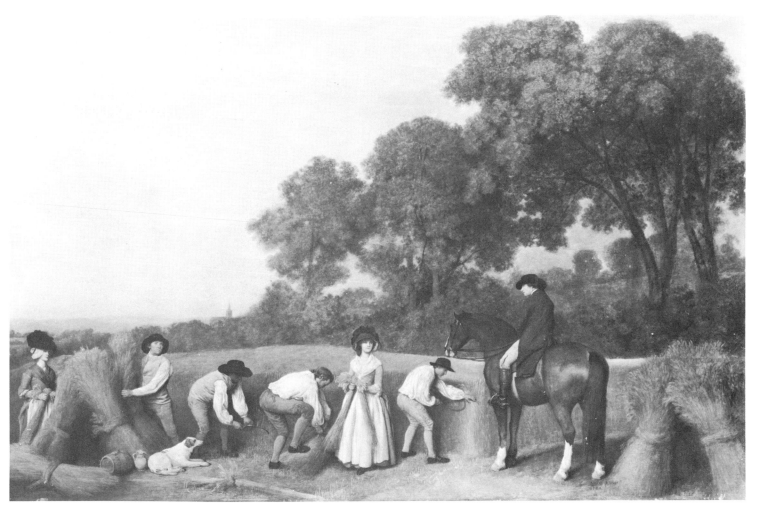

"Reapers". 35½" × 54". *Tate Gallery*

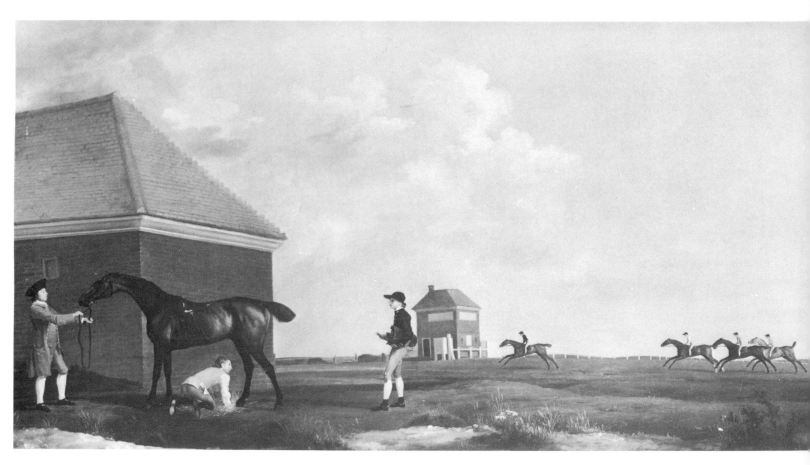

"Gimcrack". *Royal Academy of Arts*

recompense compared with some of his prices, but a help in difficult times. Unfortunately, the scheme did not last. In 1794 16 paintings were on view at the Turf Gallery in Conduit Street and these were engraved. The prints appeared in two sizes 20″ × 16″ and 10″ × 8″. Subscribers were to pay 2 guineas for each number which was to contain 3 large prints and the text illustrated by the small prints. No more appeared, possibly because insufficient thought was given to the choice of the horses. There is a feeling that Stubbs may have chosen the well-known racehorses he had already painted rather than a careful selection of the most important thoroughbreds of the day. Some, like the Godolphin, whose posthumous portrait was the first of the series, were perfectly suitable, others were not.

One of Stubbs' most sophisticated designs is in the painting of the little racehorse Gimcrack. He painted him in 1765 showing two scenes on one canvas. In the foreground to the left is Gimcrack having won his race, being rubbed down and on the right in the middle distance is the race actually happening with Gimcrack passing the winning post. The whole composition moves from right to left. The huge simple sky on the right with the tiny racing horses is balanced by the solidly constructed rubbing house on the left and, most important of all to the design is the authoritative figure of the trainer holding the horse, and, in fact holding the whole structure of the composition. Gimcrack, shown here in this painting as a young horse, is a dark pewter colour—neither grey nor roan. Stubbs' painted him again a few years later and he appeared nearly white. It was this version that was engraved for *The Turf Review*. It is odd that Stubbs who was so unwilling to accept the view of others and had to experiment and think for himself, and always referred back to nature for everything should not have been the first painter to realise that a horse does not gallop with his legs stretched out pointing front and back. However, it was not until the advent of photography that artists gradually found out that the usually accepted pose was inaccurate. It is very obvious in the painting of

"William Anderson and Two Saddle Horses". Anderson was head groom to the Prince of Wales. He rides a briskly trotting chestnut and leads a second horse who floats along in what was intended as a canter. This formalised motion gives the look of an animal suspended by a wire rather than propelled by muscular action. Stubbs' appreciation and knowledge of form prevents the normal dead look achieved by the static arrangements of the legs all off the ground at once.

According to Humphry *The Turf Review* project faded away owing to the war. Mary Spencer said after Stubbs' death that she "owned all the plates and prints as the proprietor never settled with Mr. Stubbs and only paid in part. All the pictures were sold at Mr. Stubbs sale."

With fewer commissions and with *The Turf Review* disappointments Stubbs in the mid-1790s had time to devote to the huge project he had long had in mind. Though he started work seriously on *The Comparative Anatomy* in 1795, he must surely have been thinking about it and making studies for a long time. It was thirty years since he had finished *The Anatomy of the Horse.* His experiments with enamel painting had not improved his commissions and he was hard up but, undaunted at the age of 71, he started work on this enormous task. He proposed to compare the anatomical structure of the human with that of the tiger and the common fowl. It is intriguing to speculate as to why he chose the tiger for his four-footed animal. It would have been far easier to obtain cats for his researches, dead tigers even today are not plentiful. If it was because he wanted a member of the cat family comparable in size with man, then the chicken is out of scale as the third subject of comparison.

The arrangement of the book was to be the same as for *The Anatomy of the Horse.* Pairs of plates, one fully modelled and one a simple line engraving giving the key to the descriptions in the text. The anatomical progression was to consist of subjects shown first without fur or feathers, the man naked, then four tables of dissection and the skeleton. The man is seen

53

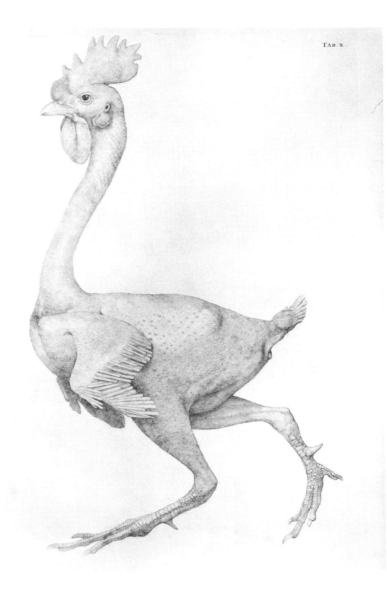

"The Common Fowl". Engraving from
The Comparative Anatomy. $21\frac{1}{2}'' \times 16''$.
Royal Academy of Arts

from the back, front and side, the tiger and the fowl from the side only. The total number of plates was to be 30. Mary Spencer wrote ". . . . he frequently worked at it from dawn of Day, in summer, till midnight, so great was the Ardour with which he engaged in this grand undertaking".

The actual engravings are different in techniques from the earlier anatomies. Instead of the modelling of the form being shown by hatching or short strokes, the plates are stippled, the light and shade produced by tiny dots. The whole effect is softer and could easily look woolly, but Stubbs manages to give a very precise delicacy to his subjects. The featherless chicken is a lesson in how to express a complex surface of "goose pimples" without losing the overall form of the bird, the intricate patterning of the scales on the legs and feet are beautifully drawn and make a fine decorative effect. As with the plates for *The Anatomy of the Horse*, each subject is displayed within the page area as a simple well designed layout. No exotic background to distract from the sculptural shapes of the information depicted with such clarity.

Stubbs' fondness for small hands and feet are very obvious in the drawings of the man, in fact, some of his proportions are decidedly curious.

His humans are short-waisted in the extreme, so much so that in some cases it is doubtful whether the ribcage and pelvis would clear each other in a sideways bend. This could perhaps be the result of the vertebrae shrinking as they dry with age. But Stubbs was an experienced anatomist and must have known about the possibility of such changes taking place. His men also have an oddly pear-shaped torso. In one or two drawings, the pelvic "basin" appears to be articulated the wrong way round. The ribcage and upwards facing front, the legs facing front but with a backview pelvis linking them. Why? Did Stubbs have some unknown theory? It must have been deliberate, he could hardly have made a mistake of that sort. Or did he acquire a skeleton that had been put together wrongly and

he merely recorded it before changing it round? Over 800 pages of text and 124 drawings have survived. Again, like *The Anatomy of the Horse* more for their information than their aesthetic value. They, like everything else that Stubbs left at his death, went to Mary Spencer. The manuscript material was bound at some point and contains the bookplates of George Bell, F.S.A., a Lecturer in Comparative Anatomy at Guys Hospital and a President of the Linnaean Society. They then found their way into the library of an American doctor, John Green of Worcester, Massachusetts. He gave his books to found the Free Public Library of Worcester and the library accession date in the Stubbs volumes of text is 1863. They remained in obscurity until nearly a hundred years later, when in recataloguing the library the volumes and collection of drawings came to light. They are now in the Mellon Collection in New Haven, Connecticut.

Stubbs worked for eleven years on *The Comparative Anatomy* and had completed three "numbers"—15 double plates in all—before he died. The Royal Academy subscribed to these in 1802 and received the first two numbers in January and December, 1804. They were unaccompanied by any text. They were of the five views of the skeletons and the three views of the naked man and the tiger without fur and the featherless fowl.

The text is written in pencil, divided in four, part in English and part in French. Stubbs is recorded as having studied French as a young man while he was in York. The book was presumably intended to be available to a wide public—possibly to be published in France as well as England. After Mary Spencer's death the 15 completed double plates were published by Orme with 280 pages of text.

Mary Spencer said that Stubbs had intended to carry his work on into the vegetable world, yet with all this desire to do experimental and scientific work he was still painting. He was in his late seventies when William Upcott visited him in 1803 and reported that he found Stubbs

. . . . engaged in engraving his series of anatomical plates, of which he had just completed his first number. This day he will have attained his seventy-nineth year and still enjoys so much strength and health that he says, within the last month having missed the stage coach he has walked two or three times from his house in Somerset Street to the Earl of Clarendon's at the Grove, between Watford and Tring, a distance of sixteen miles, carrying a small portmanteau in his hand.

In an obituary *The Gentleman's Magazine* noted that Stubbs "was always an early riser and long after he was four-score, he has often walked from Somerset Street to Fleet Street and back before the regular hour of breakfast."

Among his late paintings is one of his most memorable. The huge canvas "Hambletonian, rubbing down" is a truly magnificent horse portrait and shows that Stubbs aged 76 was no less a painter than he was in 1762 when he painted his other well-known life-size horse portrait, "Whistlejacket". Hambletonian, who won the St. Leger as a three-year-old, was matched against Diamond at Newmarket in 1799 and, after a very close race, won. The painting shows him, held by his trainer in a state of near exhaustion. The horse practically fills the canvas, the background is kept very simple, just sky and ground broken only by the rubbing-house and winning posts. All the interest is centred on the three figures. The design is interesting, the composition depends so much on the determined stance and gaze of the top-hatted trainer who holds the tired horse and acts as a buttress to the whole picture. The stable lad looks out anxiously but affectionately from under Hambletonian's neck, one hand on his withers. It seems, in this painting, that Stubbs brought together all his creative and scientific knowledge gained during a life long career. The surface forms are treated in minutest detail but they are so controlled that the overall sculptural simplicity of the animal is retained. It can be viewed

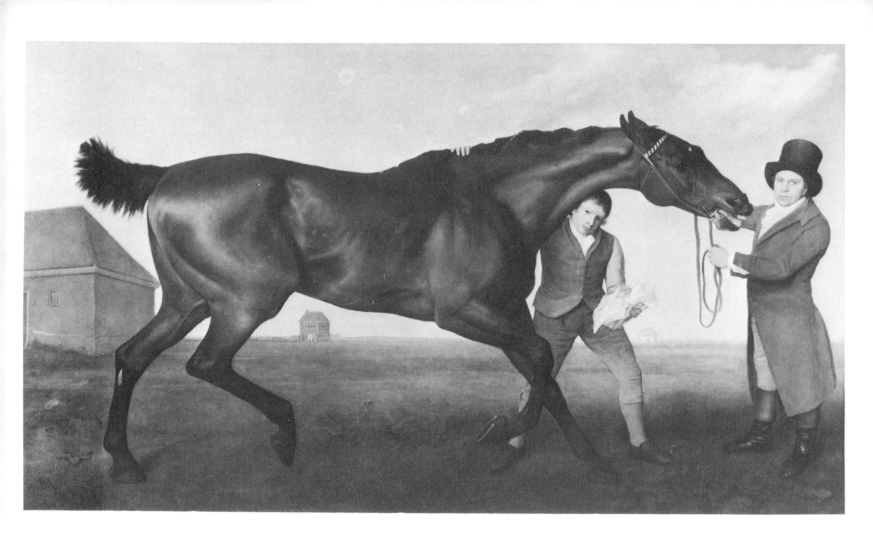

close to and from a great distance without losing any of its powerful impact. Stubbs, unlike so many horse painters, had no preconception of "The Horse". He looked at nature, not at other people's renderings of nature. He knew what a horse was like from the basic inner skeletal structure to the subtlest superficial modelling of the subcutaneous muscles.

Sir Harry Vane-Tempest, Hambletonian's owner, had two paintings done, one of the horse actually winning the race and the other was the life-size canvas of him after the race was over. If the dates are correct Stubbs completed these paintings in about two months. The race took place on March 25th and in an advertisement in *The Sporting Magazine* of May 31st, placed by Sir Harry, it states that engravings of both paintings will be available to the public by subscription and executed by the "ablest artists". He goes on to say: "These pictures are finished and engravings will be made of them as soon as possible." Stubbs eventually had to take Sir Harry to court over payment of the 300 guineas he asked for the huge canvas. Farington mentions it in his diary for April 9th, 1801 saying that Humphry and Lawrence attended as witnesses for Stubbs and that Hoppner and Opie were "very violent" against Stubbs' claim. He won his case, but the engravings were never published.

Stubbs did far less paintings in the last ten years of his life—not because of age, but because he was very much involved with *The Comparative Anatomy*, which could well have been a full-time occupation for most people, and because at the end of a very long life his work was no longer in keeping with current taste. There is a feeling of melancholy in many of his late paintings. Hambletonian is not without a stern and forbidding quality. The painting of "Freeman, keeper to the Earl of Clarendon" has a sombre gloom about it. The scene is set deep in a dark wood, the keeper parts a hound and a dying doe, the group is triangular with Freeman's head as the focal point. He, like Hambletonian's trainer, has been given a very penetrating gaze. The lighting is unlike that in most of Stubbs' works, coming

OPPOSITE PAGE

"Hambletonian". $82\frac{1}{2}'' \times 144\frac{1}{2}''$.
Private Collection

59

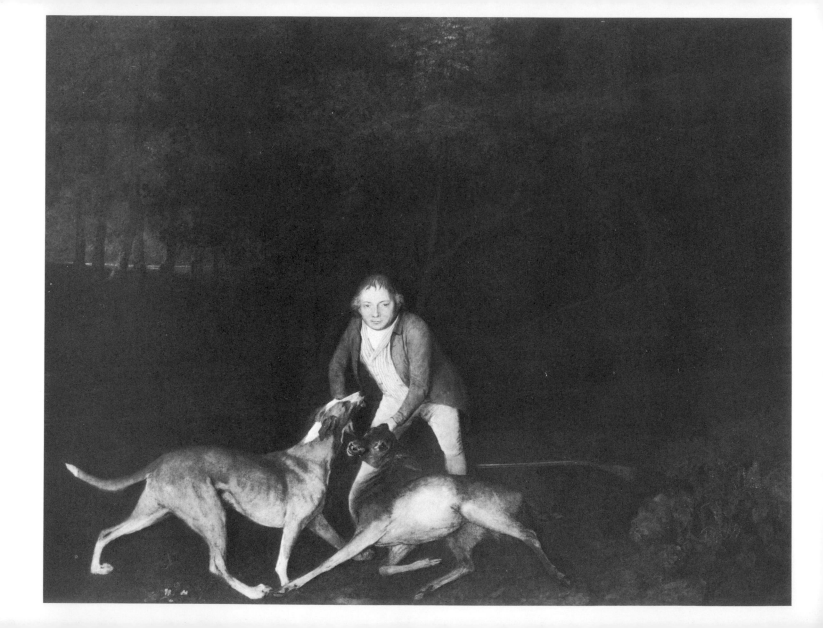

from very low down. Could it have been that after walking from Somerset Street to Watford Stubbs carried on painting until very late in the evening? Towards the 1780s he changes the trees in his usual landscapes from light, lacy springtime leaves to heavy, late summer foliage making solid dark shapes in the backgrounds. This simplifies but also a nostalgic sadness begins to creep in. Stubbs had financial problems at the end of his life. Not only were his commissions fewer but it was difficult to get clients to settle their accounts. By the time of his death he was practically penniless. Nollekens says that "when Stubbs died there was no money in the house, but about £20 was owing to him". His house was mortgaged and he owed money to one of his executors, Isabella Saltonstall, whom he had known for many years, having painted her as a child and again in 1782 as Una in the Faerie Queen. She owned many of Stubbs' paintings, having, apparently a "Bond of Security" which gave her some claim to his pictures as well as his house. He left everything to Mary Spencer, having cut out his son, George Townley Stubbs on the morning of his death. The original will was made twelve years before, when there might have been more to leave. When everything was sold up in 1807, Nollekens reports that the auction brought in "upwards of £4,000". Isabella bought in a number of works. The picture dealer, Segar, said that he understood that after her debt was paid there would be little left. There was an enormous variety in the works up for sale and it would be fascinating to see them now. Apart from a large number of his enamel paintings and those done for *The Turf Review*, there were paintings that dated back to his early years, studies in oils of the bones of the pelvis, and a sketch of "Alice Atkinson who died in York aged 110". There were pictures of flowers and birds and quite a few mythological and biblical subjects. Some of these were large canvases that Stubbs had hoped would boost his reputation and change his image from an animal painter to something more acceptable to the artistic hierarchy.

Poor Mary Spencer did not do all that well from the will. She inherited a

large quantity of works and studies left in the studio after the sale of his major works. It was sad for her to find that people were no longer so interested in buying Stubbs' paintings now that styles and fashions had changed.

By January, 1804, Dance met Stubbs and told Farington that he was "shocked at his appearance, so aged, in-jawed and shrunk in his person". But on the last day of his life he was said to have "as usual walked eight or nine miles, came home in good spirits and went to bed about nine o'clock."

He awoke in great pain and said to friends:

Perhaps I am going to die. I fear not death, I have no particular wish to live. I had indeed hoped to have finished my Comparative Anatomy eer I went, but for other things I have no anxiety.

He then must have altered his will and put his affairs in order. He appeared much better and went back to his bedroom, where he was found dead a few minutes later. He was within two months of his eighty-second birthday. Mary Spencer, who had been with him for most of his working life wrote this touching tribute:

On the 10th of July 1806, at 9 o'clock in the morning closed the career of this celebrated artist, a genius unexampled in the annals of history, in his profession unequalled, in his private life exemplary, for honour, honesty, integrety, and temperance (his general beverage water, and his food simple) possessed of a firm and manly spirit, yet with a heart overflowing with the milk of human kindness, beloved by his friends, feared by his enemies and esteemed by all who knew him. By the multiplicity and excellence of his works, he has raised a monument to himself, that will vie with time.